Nancy Kominsky's

Painting
with
Pastels

COLLINS

First published in 1986
by William Collins Sons & Co Ltd
London · Glasgow · Sydney
Auckland · Johannesburg

Designed and produced for
William Collins Sons & Co Ltd by
The Rainbird Publishing Group Ltd
40 Park Street
London W1Y 4DE

Editor: Catherine Newton
Designer: Sharon Lovett

Page 6 illustration: The Burrell Collection – Glasgow Museums
and Art Galleries. *Reading the letter* by Edgar Degas c. 1884.

Text set by SX Composing Ltd,
Rayleigh, England
Colour origination by Bridge Graphics Ltd,
Hull, England
Printed and bound by Hazell Watson & Viney,
Member of the BPCC Group, Aylesbury, Buckinghamshire, England

British Library Cataloguing in Publication Data
Kominsky, Nancy
 Nancy Kominsky's painting with pastels.
 1. Pastel drawing—Technique
 I. Title
 741.2'35 NC880

ISBN 0-00-412019-1 Hbk
ISBN 0-00-412008-6 Pbk

Contents

Nancy Kominsky

Nancy Kominsky, a native Philadelphian, is a portrait painter, international lecturer, teacher and author, who now lives in Rome. She studied at the Graphic Sketch Club, Philadelphia, Pa. Cooper Union, New York City and under Theodore Lukits, a well-known portrait painter, in California. She worked for three years painting and sculpturing on scaled dioramas for a Pennsylvania Museum.

In 1963, faced with the prospect of no income and at the urging of a friend, she opened her first Sunday Painters Art Studio in Burbank, California. She devised a unique 'anyone can paint' system of teaching which became instantly successful.

In 1966 she moved to Rome and opened the equally successful Sunday Painters of Rome Studio, teaching personnel from many embassies of the world there how to paint. She has completed four highly acclaimed networked television series of thirteen programmes each and twenty-six programmes in the United States. Her television series is currently being broadcast in places as far afield as Malaysia, Iceland and the United Arab Emirates. She has also written many very successful painting books which have been translated into several languages.

Foreword

When I first became interested in art, at a very tender age, I naturally started drawing with a pencil. Later, when I attended art school, I graduated to charcoal. Some students branched off into watercolours and oils but I started to use a set of pastels which I had received as a gift. My interest grew after having seen the marvellous pastel paintings of the famous Impressionist, Edgar Degas, such as *Reading the letter* (overleaf).

Recently I discovered an old pastel portrait of my husband's grandmother which had been painted in 1898. To my utter amazement fine sandpaper had been used as the background material. It was in a dreadful condition but I managed to restore it, with oil pastels instead of the soft chalk pastels of the original. I then decided to use the technique of oil pastels on sandpaper as the basis for a new book, incorporating the same simple step-by-step method which had been so successful in my books and television programmes about oil painting. This system, which has specific instructions, uses oil pastels, sandpaper and coloured paper and will help you produce, at the very first attempt, exciting and vibrant paintings.

Oil pastels have the brilliance of oil paints whereas soft chalk pastels tend to be tints of colour and rather difficult to use. Unlike oil paints, however, oil pastels do not require mixing and, unlike soft chalk pastels, they do not need any fixative. Oil pastels are a very clean and quick medium to work in – you can paint at anytime, anywhere and don't have to wait for your painting to dry! They are also very cheap; the outlay for all the materials is relatively little, which is practical for those with limited funds. You don't need lots of space either!

Painting with oil pastels is not difficult – it is simply a question of learning the best technique. With my straightforward system you will face a new and exciting challenge and will, I promise, be thrilled with the results.

Nancy Kominsky

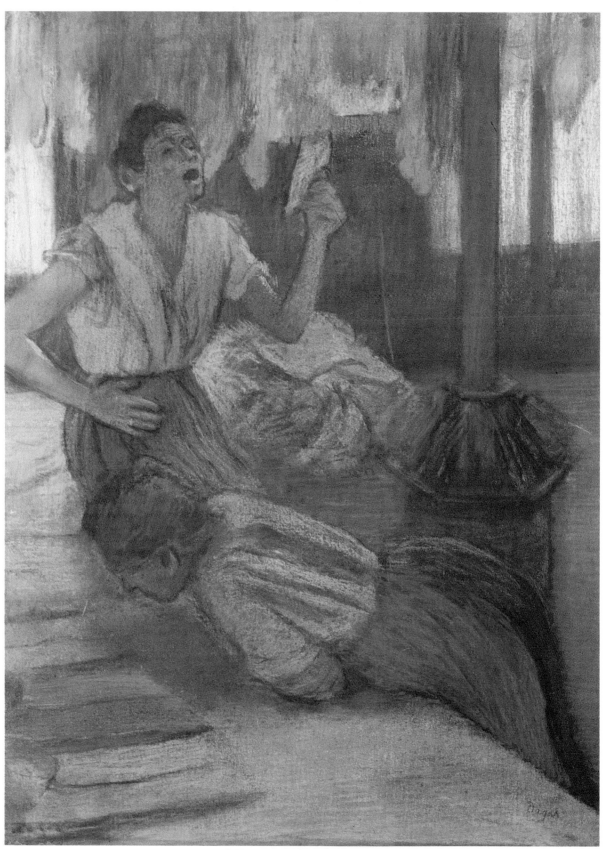

Reading the letter by Edgar Degas c. 1884

Before you paint

MAKES OF PASTEL

Read these notes carefully before starting to paint.

You can use any make of oil pastel for these pictures – a few examples are Sakura Cray-pas, Guitar and Contélor. However, make sure you don't buy the soft chalk pastels which are softer in colour and texture and which require a different painting technique. In the text I have used the most common names for each colour, e.g. Yellow Ochre or Cobalt Blue, but don't worry if your pastels have different names or even slightly different shades of the colours. Because my step-by-step method is based on tonal values, i.e. light, medium and dark shades, it will not matter if the shades themselves vary slightly from the ones in the book. All that matters is that you have the tonal values required for each stage of a painting. For example, to paint a particular object, the light tone might be Yellow Green, the medium tone Green and the dark tone Deep Green. Each of the tonal values – light, medium and dark (and extra light if necessary) – are indicated by colour swatches at the beginning of each section. If you are at all unsure of which colours to use, simply find the nearest colour match by using the shade card on this page – any differences in colour won't affect your painting.

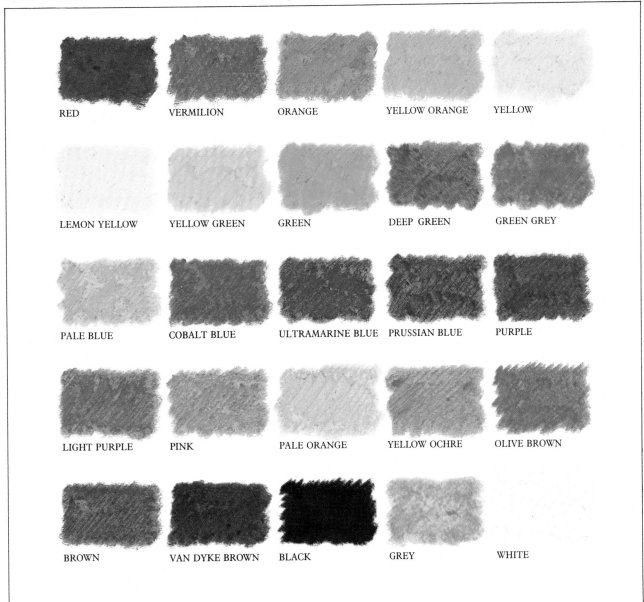

RED VERMILION ORANGE YELLOW ORANGE YELLOW

LEMON YELLOW YELLOW GREEN GREEN DEEP GREEN GREEN GREY

PALE BLUE COBALT BLUE ULTRAMARINE BLUE PRUSSIAN BLUE PURPLE

LIGHT PURPLE PINK PALE ORANGE YELLOW OCHRE OLIVE BROWN

BROWN VAN DYKE BROWN BLACK GREY WHITE

HOW MANY TO BUY

Most pastels come in boxes of 12, 24-25, and 36-40. You should buy the medium-sized box with 24-25 colours. You can buy single colours to replace any you use up, but if you are going to attempt all the paintings in the book you may find it cheaper in the long run to buy an extra box of 12 pastels which will contain all the main colours.

THE PAINTINGS

The painting projects in this book have been carefully planned to help you develop your painting skills progressively. Florals, as in the first project, *Mixed Bouquet*, are generally the easiest to begin with. As you become more experienced and familiar with your materials, and with my simplified step-by-step technique, you will be able to handle the more ambitious projects later in the book. Just keep painting!

PAINTING TECHNIQUE

The pastel should be held lightly while stroking on the colour. Do not press hard unless this is specified in the instructions. The sandpaper should not be filled in with solid colour unless indicated. In most cases the sandpaper should show through the colour. Other colours can then be blended in or added on top. This is not only an interesting effect but saves pastels! In creating form your strokes are important. For example, use round strokes for round objects. Don't panic when colouring, just paint slowly and your pictures will look lovely.

As a general rule, paint in the dark tones first, followed by the middle tones and then the light tones. Only mix tones where they meet so as not to lose tonal values or muddy the colours. This is very important to preserve the contrast between light and dark in the paintings.

WORKING WITH PASTELS

As you work you will have to remove bits of the paper label. When this happens make sure you match your pastels with the colour swatches for each painting project. It is best to take the pastels out of their box and line them up alongside your painting area. Keep them in one place – this will save both time and frustration!

SHADOWS

You will see that all the paintings take account of the shadows which are formed by light shining on one side of an object. If light is shining on the left of an object, the shadow will fall on the right. If the light is shining on the right, the shadow will fall on the left. Paint the shadows in lightly at first – you can always darken them later.

MOUNTING YOUR PICTURES

Your pictures will look much more professional, and larger, if you mount them. One of the easiest ways is to use coloured paper – any sort will do, but if it is slightly stiff it will provide some support for your painting. Choose a colour that will tone with the painting, for example, brown for *First Snow* or yellow for *Fruit and Flowers*. The mounting paper should ideally be about 8cm (3in) larger all round than your painting. Place the painting in the centre and mark the corners lightly on the mounting paper. Using a little clear glue; carefully stick down the painting using the pencil marks as guidelines. Don't use too much glue as it might soak through the paper and spoil your painting. You can, if you wish, then frame your picture under glass. You can buy simple picture frames quite inexpensively from stores and art shops.

PAINTING MATERIALS

The following is a list of pastels and other painting materials required for the eleven paintings in the book.

1. Pastels
(a) One set of 24-25 oil pastels.
(b) Two extra sticks of white oil pastel.

2. Pencils
(a) Two HB lead pencils.
(b) One thin or medium charcoal pencil.
(c) One purple pastel pencil (Contélor Number 5).

3. Double pencil sharpener

4. Erasers
Two kneadable putty erasers for erasing grids etc.

5. Drawing paper
To paint all the pictures in this book you will need nine pieces of medium fine sandpaper and two pieces of coloured paper. They can be any size but I used, and can recommend: eight pieces of medium fine sandpaper 23×30cm (9×12in) and one piece of medium fine sandpaper 30×35cm (12×14in). You can buy very large pieces of sandpaper and cut them to size. Painting on sandpaper gives an exciting texture but you can, if you wish, paint on sugar paper (construction paper). You will also need two pieces of light blue paper 23×30cm (9×12in). You can use blue sugar (construction) paper or Ingres drawing paper which is widely available.

6. Mounting paper
See the note on mounting your pictures on page 8.

7. Easel
Use whatever is available, but I think a table easel is best. Not only does it fold away, but the table on which you place the easel provides a good surface to hold your painting equipment (see illustration).

8. Drawing board
This is to place on your easel to support your paintings. You don't have to buy one especially but can use any available stiff cardboard. Make sure it is larger than your painting.

9. Work area
You can use any space available. Pastel painting requires very little space for preparation and cleaning up.

10. Scrap paper
Two extra pieces of sandpaper – any size. These are to clean the pastels before going from one colour to another. Scrape the tip of the pastel, and the sides if necessary, lightly in a circular motion on the sandpaper. Clean pastels mean that you will have better results.

11. Container
To hold pencils and other supplies.

12. Small sponge
A damp sponge is essential to keep fingers clean while working so as to avoid smudging the painting.

13. Plastic container
For litter and pencil sharpenings.

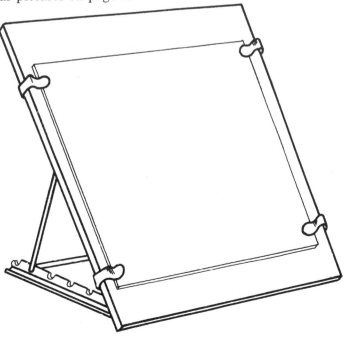

Table easel

PAINTING PROCEDURE

These are the general guidelines for the method you will follow at the beginning of each painting project.

1. Sectioning the sandpaper or coloured paper

Use a pencil to draw the grids. If your paper is to be used vertically, draw three equally spaced vertical lines and five equally spaced horizontal lines. If your paper is to be used horizontally, draw five equally spaced vertical lines and three equally spaced horizontal lines. When doing this, a useful tip is to divide the paper into quarters first, then divide each section as indicated in the illustration. The sections do not have to be measured exactly. This method of sectioning-off the paper can be used for any size paper. On larger paper the squares will be larger but so will the scale of the drawing.

2. The drawing

For each project study the drawing carefully. Start at the bottom of the paper and mark a place for the objects before drawing them in. This helps with sizing and correct placement. Pencil in the drawing, which is a simplified form of the finished painting.

The detail is put in later. Use the squares as guidelines. Put objects such as vases in a box, again using the squares as guidelines to make sure that both sides are equal. Decide where the light is coming from and pencil in the areas of shadow lightly. Erase any mistakes and then outline the objects and paint in the shadow areas lightly again but this time with the purple pastel pencil. *Don't outline the grid lines or they will show through the colour you add later.* Now erase the grid lines lightly and carefully. They were simply used to place your objects correctly. You will find that your pencil drawing will fade so you must outline it quickly with the purple pastel pencil. Make sure you don't outline the grids.

NOTE

One of the most difficult lessons to learn is when to stop. If you overwork your painting it will not only lose its spontaneity but you may very well lose the painting.

Mixed Bouquet

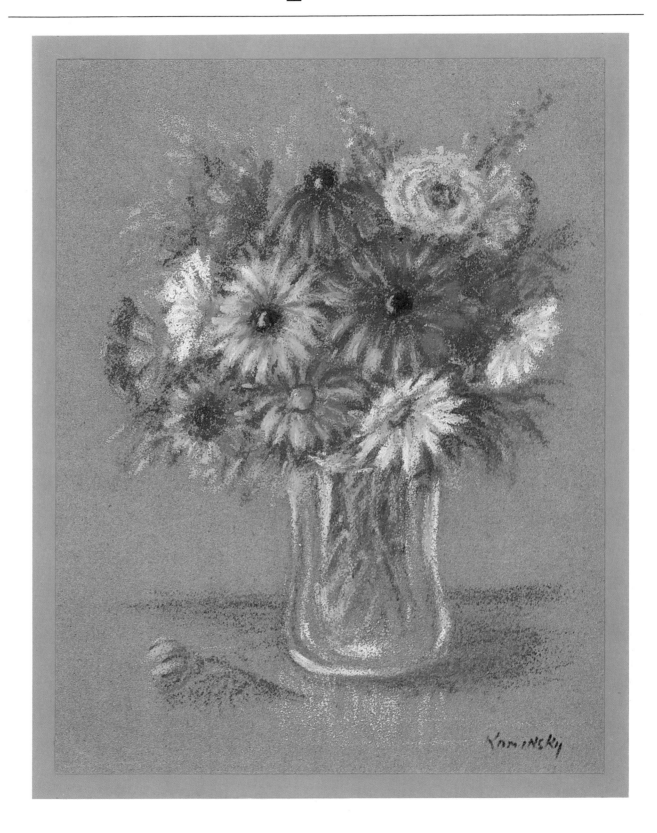

THE DRAWING

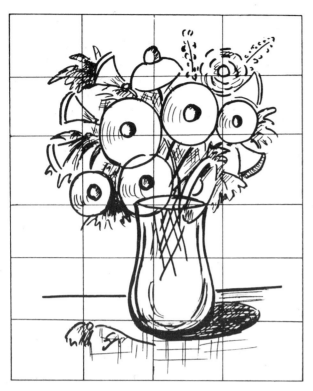 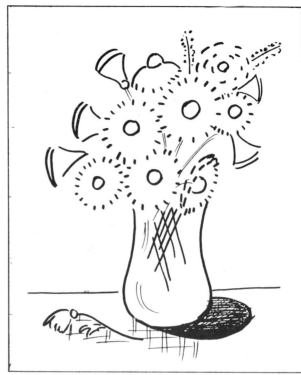

1. Use sandpaper 23×30cm (9×12in) placed vertically. (You can of course use a smaller or larger piece of sandpaper as long as you keep everything in proportion. By using the grid system your subject will be placed correctly.)

2. Study the painting and drawings on pages 11 and 12 carefully.

3. Draw the grid lines in pencil (see page 10) and then, also in pencil, sketch in the simplified picture as shown above left.

4. The light is coming from the left (note the shadows of the vase on the right) so lightly shade in the area on the right side of the vase with pencil.

5. Take the purple pastel pencil and outline the flowers and vase lightly as shown above right. Also lightly paint in the shadow with the purple pastel pencil. This preserves the essential part of the drawing. The rest of the pencil lines which you do not need will fade quickly as you work. (Do NOT draw the grid lines in purple.)

6. Erase all the grid lines, leaving the purple outline intact (see above right). Pencil lines are easily erased, but if they are outlined in purple pastel pencil they cannot be erased and will show through the background of the painting.

THE PAINTING

NOTE

As you work you will have to remove bits of the paper wrapper from the pastels. Make sure you match your pastels and their names with the squares of colour selected for each painting.

Background

Usually the background is put in first. However, in this painting the sandpaper itself provides the background.

Glass Vase

If the vase to be painted is opaque, such as pottery or china, then it is usually painted in before the flowers. Here, however, it will be painted in after the flowers as the stems are to be visible through the glass.

Flowers

1. Study the painting carefully. Because this is a multi-coloured floral, it makes sense and saves time to paint all the flowers of the same colour at one time. You can then go on to a second colour.

2. Study the three stages of the flower head illustrated before starting to paint, as this method can be applied to all the flowers whatever their colour. For vibrant colours press down hard on the pastels.

ORANGE FLOWERS

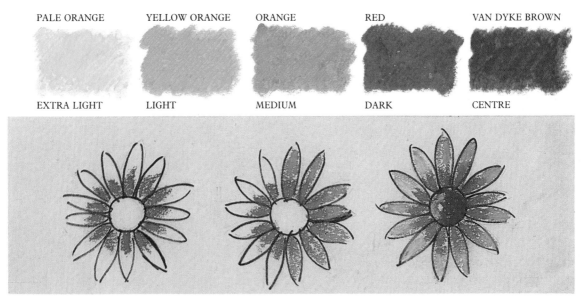

1. Study the orange flowers in the finished painting and in the step-by-step illustration.

2. You may find it easier to pencil in the petals lightly first, leaving the short purple strokes as shaded areas between the petals. Paint the dark tone (Red) in the area around the centre of the large orange flower.

3. Paint the right side of the flower in the medium tone (Orange).

4. Paint the left side in the light tone (Yellow Orange) and paint the tips of these petals with the extra light tone (Pale Orange).

5. Paint the left profile flower with the medium tone (Orange) around the centre. The tips are painted with the light tone (Yellow Orange) highlighted with the extra light tone (Pale Orange).

6. Paint the centre profile flower with the dark tone (Red) near the centre. Paint the right tips in the medium tone (Orange) and the left tips with the light tone (Yellow Orange) highlighted with the extra light tone (Pale Orange).

7. Paint the centres in Van Dyke Brown with a touch of Yellow as a highlight.

YELLOW FLOWERS

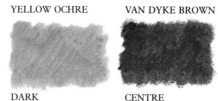

LEMON YELLOW	YELLOW	YELLOW OCHRE	VAN DYKE BROWN
LIGHT	MEDIUM	DARK	CENTRE

1. Study the yellow flowers in the finished painting.

2. Starting with the large flower, paint the dark tone (Yellow Ochre) in the area towards the centre.

3. Paint the right side of the flower in the medium tone (Yellow).

4. Paint the left side in the light tone (Lemon Yellow) and paint the tips of these with a little White.

5. Paint the centre in Van Dyke Brown with a highlight of Yellow.

6. The structure of the flower on the upper right is a little different. Look at it carefully. The strokes are round, but the same yellow tones are applied in the same areas, on the right and left sides, with the exception of the dark tone (Yellow Ochre) in the central area which is omitted. The centre is Van Dyke Brown.

7. The small yellow flower on the lower left has Red around the centre with touches of Orange on the right side and the medium tone (Yellow) on the left. The centre is Van Dyke Brown.

WHITE FLOWERS

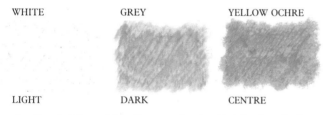

WHITE	GREY	YELLOW OCHRE
LIGHT	DARK	CENTRE

1. Study the white flowers in the finished painting.

2. The flower on the lower right is in semi-profile. Paint the area around the half centre in the dark tone (Grey).

3. Paint the short petals and the right side of the flower in the light tone (White).

4. Paint the centre in Yellow Ochre with a highlight of Yellow.

5. Paint the two profile flowers on either side by using the dark tone (Grey) near the stem and the light tone (White) on the tips.

BLUE FLOWERS

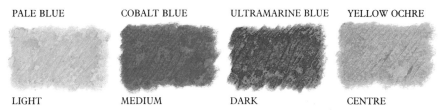

PALE BLUE COBALT BLUE ULTRAMARINE BLUE YELLOW OCHRE

LIGHT MEDIUM DARK CENTRE

1. Study the blue flowers in the finished painting.

2. Paint the upper petals of the full blue flower in the dark tone (Ultramarine Blue).

3. Paint several petals on the right in the medium tone (Cobalt Blue) and the other petals in the light tone (Pale Blue). Paint the tips of the light tone with a little White.

4. Paint the centre in Yellow Ochre with a highlight of Yellow.

5. Paint the profile flowers with the light tone (Pale Blue) near the stem and the dark tone (Ultramarine Blue) on the outer petals.

6. Paint the small flowers on the spiked stems in the upper right corner as impressions rather than full flowers. Use the light and dark tones (Pale Blue and Ultramarine Blue).

LEAVES

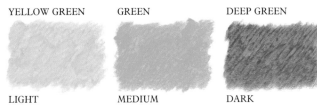

YELLOW GREEN GREEN DEEP GREEN

LIGHT MEDIUM DARK

1. Study the leaves in the finished painting and also the purple strokes you can see between the flowers.

2. Before painting in the leaves, carefully stroke Purple between the flowers and into the edges of the petals as shown. This creates depth and shadow.

3. The leaves are delicate and lacy; they look more like impressions than detailed illustrations. Paint the leaves on the right in the dark tone (Deep Green) and medium tone (Green). Keep the dark tone around the flowers and the medium on the outside edge.

4. Paint the leaves on the left (or light) side in the medium tone (Green) and the light tone (Yellow Green). Keep the medium tone around the flowers and the light tone on the edges. Tip this light tone with a highlight of Yellow.

STEMS

1. Study the finished painting. The stems in the vase should look as if they are crossed. Use the same tones as for the leaves.

2. Paint the tops of the stems in the dark tone (Deep Green) with the medium tone (Green) lower down and the light tone (Yellow Green) around the base.

3. Paint the green stem and a few leaves of the flower lying on the table. Paint the flower as an impression with some yellow and orange tones.

VASE

1. Study the vase in the finished painting and in the step-by-step illustration. Re-outline it in Purple.

2. Paint a very little Pale Blue around the inside edge of the vase and add White highlights where shown – on the sides and base of the vase and around the top, painting over the stems.

SHADOW

1. Study the finished painting.

2. Paint a soft line in Purple to give an impression of a table.

3. Paint the shadow of the vase on the right in Purple with highlights of blue and green tones.

Congratulations! You have finished your first project. It will get easier!

Summertime

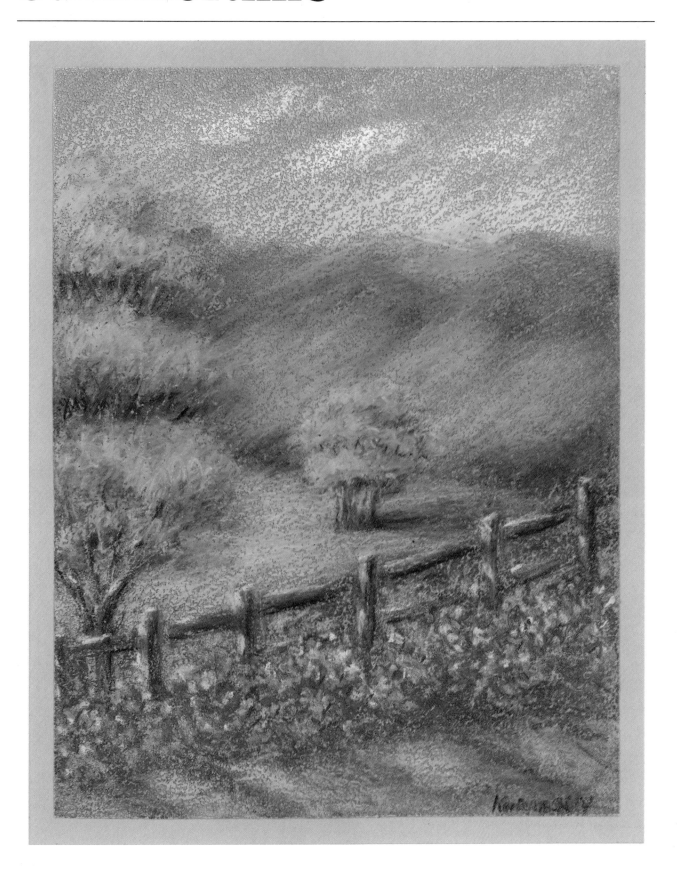

THE DRAWING

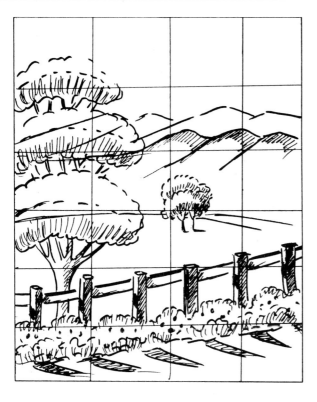 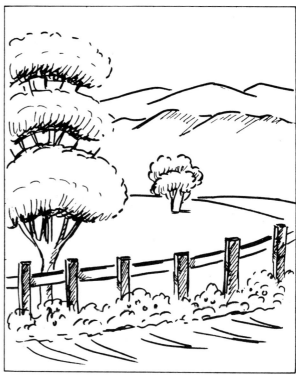

1. Use sandpaper 23×30cm (9×12in) placed vertically.

2. Study the painting and drawings on pages 17 and 18 carefully.

3. Draw the grid lines in pencil (see page 10) and then, also in pencil, sketch in the simplified picture as shown above left.

4. The light is coming from the left (note the shadows of the objects on the right) so lightly shade in the areas on the ground and by the far tree in pencil.

5. Take the purple pastel pencil and outline the objects and paint in the shadow lightly as shown above right. This preserves the essential part of the drawing. The rest of the pencil lines which you do not need will fade quickly as you work. (Do NOT draw the grid lines in purple.)

6. Erase all the grid lines leaving the purple outline intact (see above right). Pencil lines are easily erased, but if they are outlined in purple pastel pencil they cannot be erased and will show through the background of the painting.

THE PAINTING

SKY

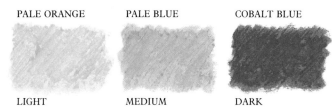

PALE ORANGE · LIGHT
PALE BLUE · MEDIUM
COBALT BLUE · DARK

Note

Until you have a bit more experience it is easier to paint all your skies in a similar fashion. Use these instructions as general guidelines each time you want to paint a sky.

1. Study the finished painting.

2. Paint the light tone (Pale Orange) along the horizon in upward slanting strokes.

3. Add the medium tone (Pale Blue) to the rest of the sky using the same slanting strokes. The sandpaper should still show through.

4. Paint a very little dark tone (Cobalt Blue) at the top of the sky, blending it with the other tones.

5. Paint some white patches in the sky for clouds as shown.

MOUNTAINS

LIGHT PURPLE · LIGHT
PURPLE · DARK

1. Study the finished painting. Notice that the mountains are formed by a soft undulating line and that there are no sharp points.

2. Lightly paint the dark tone (Purple) on the right side of the mountain. Use slanting downward strokes.

3. Paint the left (or light) side in the light tone (Light Purple) using slanting strokes again. Try to keep the colours soft and hazy, as the mountains are seen from a distance.

4. Add a little Pale Blue and Pink over the light tone (Light Purple) but be careful not to lose all the separate colours.

HILLS

YELLOW GREEN · LIGHT
GREEN · MEDIUM
DEEP GREEN · DARK

1. Study the finished painting.

2. Paint the right side of the hills in the medium tone (Green). Use the same slanting, downward strokes.

3. Paint the left (or light) side in the light tone (Yellow Green). Add Pale Blue and White lightly over the two tones to give the impression of distance.

4. Add some vegetation on the top of the hills using the dark tone (Deep Green) and soften it gently with Light Purple as shown. Stroke the same Purple at the base of the hills adding a little Deep Green as well.

FIELD

1. Study the finished painting. Use the same tones as for the hills.

2. Paint the field behind the fence in the light tone (Yellow Green). Use a horizontal stroke this time.

3. Paint Lemon Yellow over the Yellow Green on the left (or light) side.

4. To colour the field in front of the fence, paint alternate strokes of the dark and light tones (Deep Green and Yellow Green) as shown. Do not cover the area where the flowers are to go – if you do it will be difficult to achieve the bright tones required for the flowers.

5. Paint a little Purple and Deep Green in front of the flower area to create some shadow. Add some Purple shadows to the right side of the small trees in the distance also.

TREES

YELLOW GREEN GREEN DEEP GREEN VAN DYKE BROWN

LIGHT MEDIUM DARK TREE TRUNK

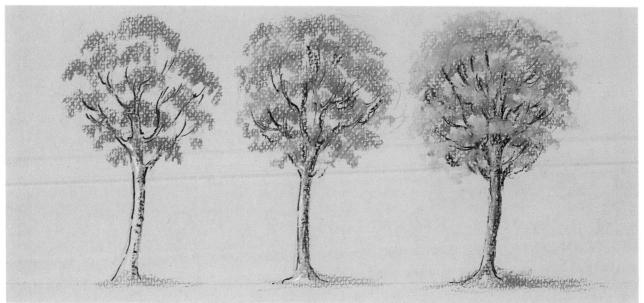

Note

These are general guidelines for painting trees. Read these carefully first before going on to the specific instructions for the trees in this picture.

1. Study the step-by-step illustration carefully.

2. Paint the structure of the tree in Van Dyke Brown. Outline it if necessary in black charcoal.

3. To paint the foliage add short strokes of the dark tone (here it is Deep Green) across the branches and trunk – see the first step.

4. Add similar strokes of medium tone (here, Green) on top of the dark tone – see the second step.

5. Use the light tone (here, Yellow Green) on the light side of the tree. In this illustration this is the left side. You can then add a lighter colour (e.g. White) as a highlight.

6. Paint a shadow under the dark side of the tree using Purple and the dark tone as shown. If you need extra shadow on the tree itself, add Purple underneath the tones.

LARGE TREE

1. Study the finished painting. Notice that there are 3 distinct 'layers' of leaves on this tree, separated by branches. Follow the basic instructions as above, keeping the areas apart. Use the colour tones illustrated above.

2. The light is falling on the left side of the tree. Therefore add the light tone (Yellow Green) to the left.

3. Use White as a highlight on the Yellow Green.

4. Add a little Purple beneath each layer to create some shadows.

5. Outline the trunk and branches again in black charcoal. It should be slightly darker on the right side. Use Brown and Blue to highlight the trunk and a little Pale Orange as highlight on the branches.

SMALL TREE

1. Study the finished picture. Notice that this is a group of three trees as seen from a distance, so outline the trunks very softly in black charcoal. Use the same tones as for the large trees.

2. Follow the basic instructions as above, blending the different tones together a little. Remember, however, to keep the dark tone (Deep Green) distinct on the right (shady) side and the light tone (Yellow Green) distinct on the left.

3. Add a very little Brown and Blue to the trunk and highlight with Pale Orange.

4. Highlight the foliage with Pale Orange as shown and add a few light strokes of black charcoal across the tree to give the impression of branches.

FENCE

BROWN VAN DYKE BROWN

LIGHT DARK

1. Study the finished painting.

2. Using the light tone (Brown), paint the top of the rails and the left side of the posts.

3. Paint the dark tone (Van Dyke Brown) on the front of the posts and underneath the light tone at the bottom of the rails. Add a very little Black over the Van Dyke Brown.

4. Paint highlights where indicated with Pale Orange and Blue.

FLOWERS

YELLOW ORANGE RED

LIGHT MEDIUM DARK

1. Study the finished painting.

2. Using the stated tones, paint impressions of flowers as shown. Press down hard on the pastels for vibrant colours. Add Yellow Green and Deep Green among the flowers to suggest leaves.

Vegetable Still Life

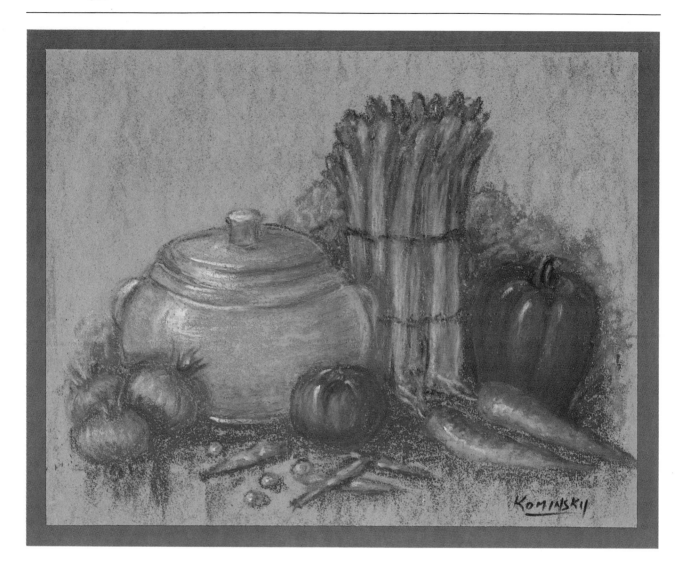

1. Use sandpaper 23×30cm (9×12in) placed horizontally.

2. Study the painting and drawings on pages 22 and 23 carefully.

3. Draw the grid lines in pencil (see page 10) and then, also in pencil, sketch in the simplified picture as shown opposite above.

4. The light is coming from the left (note the shadows of the objects on the right) so lightly shade those areas on the right in pencil.

5. Take the purple pastel pencil and outline the objects and paint in the shadow lightly as shown opposite below. (Do NOT draw the grid lines in purple pastel pencil.)

6. Erase all the grid lines, leaving the purple outline intact (see opposite below).

THE DRAWING

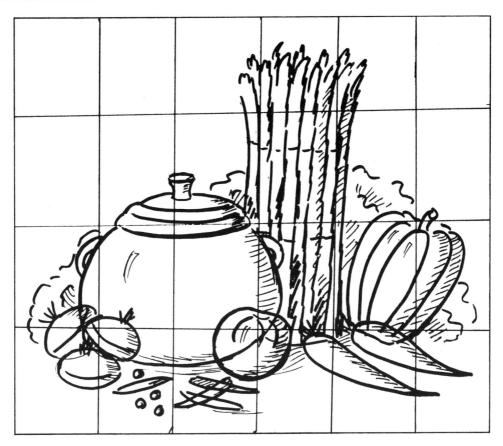

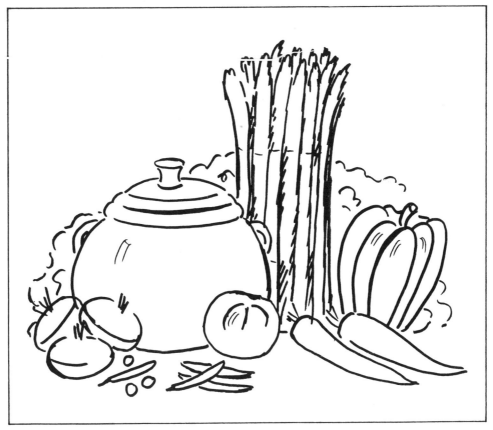

THE PAINTING

BACKGROUND

1. Study the finished painting. Note that the sandpaper forms most of the background and that there is very little colour to add.

2. Use the side of the Yellow Ochre pastel to paint the whole of the background in light vertical strokes.

Paint up to and in front of the vegetables. Most of the sandpaper should still show through. You will, of course, have to remove the wrapper from the pastel to paint in this way.

PARSLEY

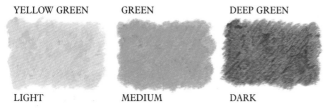

YELLOW GREEN GREEN DEEP GREEN

LIGHT MEDIUM DARK

1. Study the finished painting. Note that objects in the background are always painted first.

2. Using short, round strokes paint the dark tone (Deep Green) around the pepper as far as the carrots. Paint the medium tone (Green) in the area above the pepper. Try to keep your strokes lacy and loose.

3. Using a little of the medium tone (Green) paint the parsley to the left of the asparagus and the soup tureen. Top it with the light tone (Yellow Green).

ASPARAGUS

1. Study the finished painting. Note that the asparagus stalks are not perfectly straight! Use the same tones as for the parsley.

2. Paint the stalks at the back in the dark tone (Deep Green). Note that they lean a little to the right. Try to keep your outlines soft.

3. Outline the right side of the stalks in front with the medium tone (Green). Fill in the stalks with Yellow Ochre. Note that the third stalk from the left has

almost disappeared behind the others and has no tip. Paint this with the dark tone (Deep Green) and a little Yellow Ochre. Try to make the stalks slightly uneven. Shade a little Purple between the front stalks.

4. Using Deep Green and Yellow Ochre paint two braided strings around the asparagus. Add a rounded Purple shadow where the tureen stands in front of the asparagus.

SOUP TUREEN

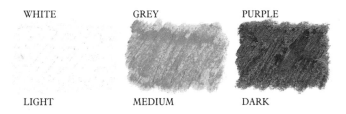

WHITE GREY PURPLE

LIGHT MEDIUM DARK

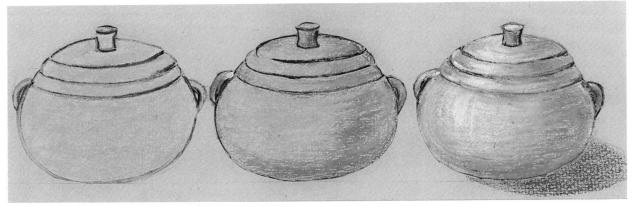

1. Study the finished painting and the step-by-step illustration. Keep your strokes rounded, following the lines of the tureen. This way you will achieve the form and texture of porcelain.

2. With horizontal strokes, paint the tureen in the medium tone (Grey).

3. Outline the tureen again with the purple pastel pencil. Shade the right side and bottom of the tureen in Purple. Take care with the lid and lid handle.

4. Using curved strokes, add highlights in White to the left side of the tureen as shown. They should be painted about 2cm (1in) into the tureen, on the lid, lid handle and on the tops of the two side handles. Take care as these highlights are important.

PEPPER

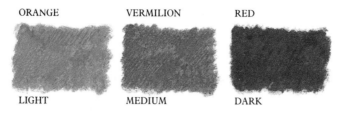

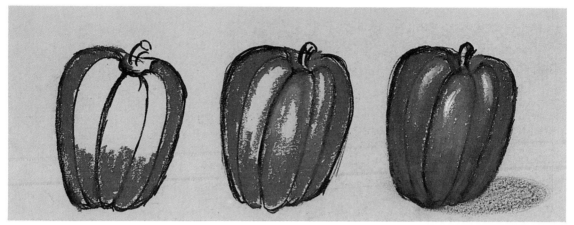

1. Study the finished painting and the step-by-step illustration. Notice that the pepper is painted in 'sections'.

2. Paint the bottom, left and right sides of the pepper in the dark tone (Red), as shown in the first step. Outline each section in the same tone. Paint the area around the stem with the dark tone (Red) on the left and the medium tone (Vermilion) on the right.

3. Use the medium tone (Vermilion) to paint the 3 middle sections as shown in the second step. Paint a little Vermilion in the left section and a little more in the centre section. The right section is mostly Vermilion.

4. Using the light tone (Orange), paint in the remainder. Be careful not to lose the other tones.

5. Paint the curved stem in Black pastel with a touch of Green.

6. Paint the White highlights on the pepper as shown.

TOMATO

1. Study the finished painting. Use the same colours as for the pepper.

2. Paint the right side and bottom of the tomato in the dark tone (Red).

3. Paint the centre in the medium tone (Vermilion).

4. Paint the light tone (Orange) on the left (or light) side.

5. Paint the stem with Deep Green on the right side and Yellow Green on the left side, giving the impression of sections.

6. Add White highlights where shown.

CARROTS

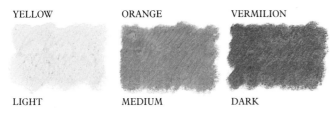

YELLOW ORANGE VERMILION

LIGHT MEDIUM DARK

1. Study the finished painting.

2. Using slightly curved strokes, paint the right side and top of the carrots in the dark tone (Vermilion).

3. Paint the medium tone (Orange) and the light tone (Yellow) on the extreme left. Make the carrots look uneven.

4. Add a wavy line of Lemon Yellow down the centre of the carrots as a highlight.

5. Paint the leafy tops of the carrots with Deep Green and Yellow Green as shown.

6. Add a touch of Pale Blue at the top of the carrots and a little Purple as shadow.

ONIONS

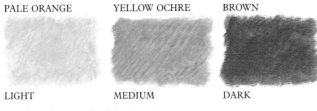

PALE ORANGE YELLOW OCHRE BROWN

LIGHT MEDIUM DARK

1. Study the finished painting.

2. Paint the onions in the medium tone (Yellow Ochre).

3. Add dark tone (Brown) to the right side and the bottom of the onions.

4. Paint the highlight in the light tone (Pale Orange) with small curved strokes across the centre of the onion.

5. Paint the onion tops in the dark and light tones.

SHADOWS

1. Study the shadows in the finished picture. Paint Purple shadows under and around the vegetables and soup tureen as shown. Be careful to leave some space to paint the peapods.

PEAS

1. Study the finished painting. Use the same tones as for the parsley.

2. Paint the right side of the peapods in the medium tone (Green) and outline with a little Purple.

3. Paint the left side in the light tone (Yellow Green) and add a few highlights of White as shown.

4. The single peas on the table are painted with the medium tone (Green) on the right and the light tone (Yellow Green) on the left. Add tiny touches of White as highlights and some Purple underneath as shadow.

First Snow

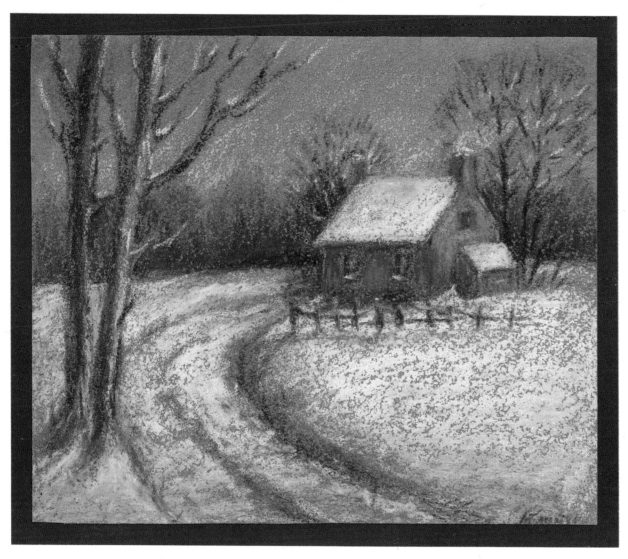

1. Use sandpaper 23×30cm (9×12in) placed horizontally.

2. Study the painting and drawings on pages 28 and 29 carefully.

3. Draw the grid lines in pencil (see page 10) and then, also in pencil, sketch in the simplified picture as shown opposite above. You can also refer to the first step of the step-by-step illustration on page 31 for hints on sketching in the house.

4. The light is coming from the left (note the shadows of the objects on the right) so lightly shade in these areas with pencil.

5. Take the purple pastel pencil and outline the objects and paint in the shadow lightly as shown opposite below. Don't outline the top branches of the large trees – you will paint in the sky first and then add the branches. Also, don't outline the fence – you will paint this in at the end.

6. Erase all the grid lines, the fence and the top branches of the large trees, leaving the purple outline intact (see opposite below).

THE DRAWING

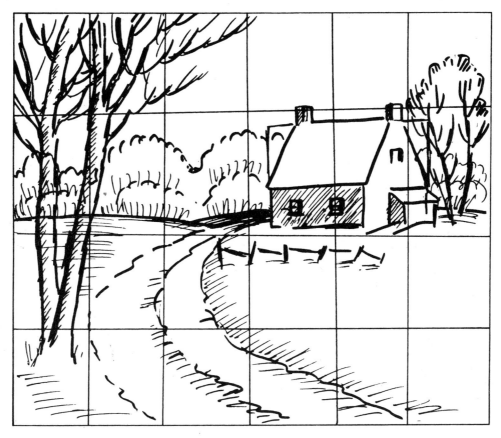

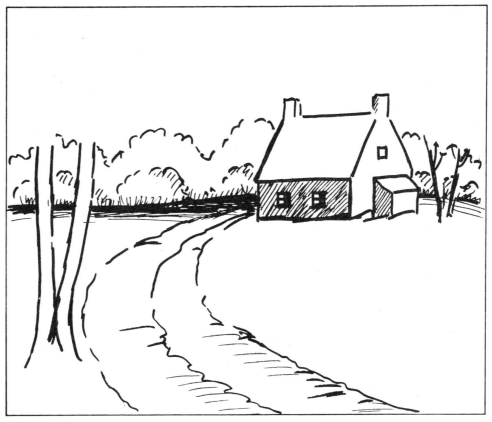

THE PAINTING

SKY

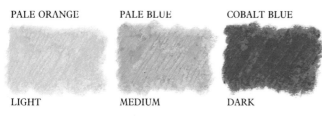

PALE ORANGE PALE BLUE COBALT BLUE

LIGHT MEDIUM DARK

1. Study the finished painting.

2. Using upward strokes, paint the light tone (Pale Orange) along the long bank of trees on the horizon.

3. Paint the rest of the sky in the medium tone (Pale Blue). Use the same upward strokes.

4. Paint a little dark tone (Cobalt Blue) at the top of the sky and blend it with the other tones.

5. With the purple pastel pencil draw in the tops of the trees which you earlier erased.

BANK OF TREES ON HORIZON

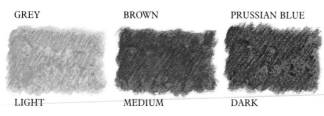

GREY BROWN PRUSSIAN BLUE

LIGHT MEDIUM DARK

1. Study the finished painting. Note that the trees are uneven in height and are hazy and indistinct. They should be painted as impressions rather than definite outlines.

2. Using upward strokes of uneven height, paint the dark tone (Prussian Blue) at the base of the bank of trees. Be careful not to make your strokes too long.

3. Layer the medium tone (Brown) over the top half of the Prussian Blue lines.

4. With the light tone (Grey) paint the tops of the trees. Again, try to keep the trees at varying heights. Add a little Purple to the Grey.

HOUSE

1. Study the finished painting and the step-by-step illustration. Note that the roof will be painted in at a later stage.

2. Paint the front of the house in the medium tone (Yellow Ochre) with a touch of the dark tone (Brown) under the eaves. Add Purple to the eaves as shown in the first step. Paint the front of the wood shed in the same tones.

3. Paint the side of the house and the wood shed in the light tone (Yellow), shading a little dark tone (Brown) at the bottom. Paint the chimneys in the dark and light tones (Brown and Yellow).

4. Paint the windows with black charcoal pencil and touches of Pale Blue and Orange. Keep the outlines soft and hazy.

5. Add Pale Blue and White to the house as highlights where shown.

SNOW

1. Study the finished painting.

2. Use a very little of the dark tone (Brown) to paint the ruts in the road. Soften them with the medium tone (Grey), especially around the deep rut on the right. This gives the impression of the house being set slightly above the road. Highlight with a very little Pale Blue. Darken the ruts here and there with the black charcoal pencil.

3. Paint the medium tone (Grey) across the bottom of the painting and over the left side around the large trees.

4. Paint the light tone (White) over the mound on the right side, and the road and ground on the left. Use horizontal strokes and press down hard on the pastel for a strong colour. Blend the White in with the Grey where the two colours meet.

ROOF

1. Study the finished painting. Use the same tones as for the snow.

2. Paint the light tone (White) over the roof of the house and wood shed. Add a touch of medium tone (Grey) to the left side of the roof to form the shadow.

TREES AROUND THE HOUSE

1. Study the finished picture.

2. Outline the trees with the black charcoal pencil. Using short, fan-like strokes paint the tops of the branches in Brown. Add strokes of White and a little Pale Blue as highlight.

LARGE FOREGROUND TREES

GREY BROWN

LIGHT DARK

1. Study the finished picture.

2. Paint the left side of the trees in the dark tone (Brown) and the right side in the light tone (Grey). Outline the trees with the black charcoal pencil. The trees should look graceful.

3. Highlight the branches with Pale Orange and Pale Blue as shown.

FENCE

1. Study the finished painting. Note that the fence is broken and uneven.

2. Using delicate, uneven strokes paint the fence with the black charcoal pencil.

3. Add a little Pale Blue as a highlight.

4. Using White, paint a faint impression of smoke coming out of the chimney.

Pink Shrub Rose

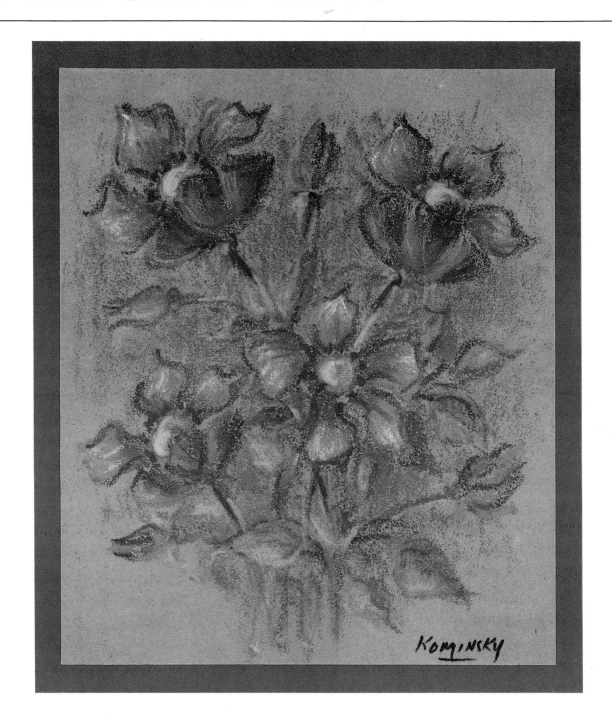

THE DRAWING

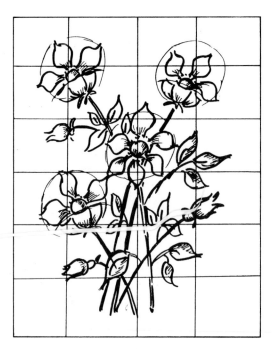 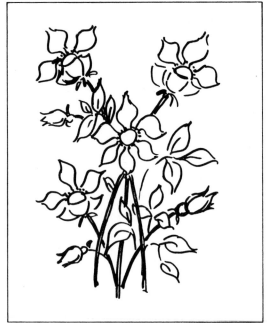

1. Use sandpaper 23×30cm (9×12in) placed vertically.

2. Study the painting and drawings on pages 33 and 34 carefully.

3. Draw the grid lines in pencil, and then, also in pencil, sketch in the simplified picture as shown above left. You can pencil in some circles to help you place the flower heads.

4. The light is coming from the left (note the shadows on the right of the flowers and leaves) so lightly pencil in these areas.

5. Take the purple pastel pencil and outline the objects lightly as shown above right. (Do NOT draw the grid lines in purple.)

6. Erase all the grid lines, leaving the purple outline intact (see above right).

THE PAINTING

BACKGROUND

1. Study the finished painting. Note that the background colour is very light.

2. Using Light Purple, lightly shade in the area between the flowers. Use the side, not the tip, of the pastel.

FLOWERS

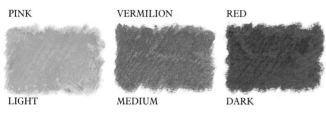

PINK VERMILION RED

LIGHT MEDIUM DARK

1. Study the finished painting. Start by painting the inside edges of the petals first.

2. Using short strokes, paint the area around the stamens in the medium tone (Vermilion).

3. Paint the rest of the petals in the light tone (Pink). Note that the lower petals on the two uppermost flowers are in 3 'sections'. Paint the right side of each section in the dark tone (Red). Add the medium tone (Vermilion) to the middle and a touch of Pink to the left.

4. Outline all the flowers in the dark tone (Red). Try to keep your strokes fluid – the petals should not look static. Paint the little buds in the light tone (Pink), outlined in the medium tone (Vermilion).

CENTRES, LEAVES AND STEMS

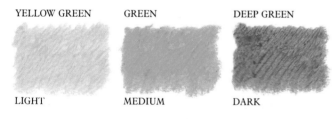

YELLOW GREEN GREEN DEEP GREEN

LIGHT MEDIUM DARK

1. Study the finished painting.

2. Using round strokes, paint the centres using the light tone (Yellow Green) on the right and Lemon Yellow on the left. Paint the stamens as purple dots around the centres.

3. The top parts of the stems are painted in the dark tone (Deep Green) with the light tone (Yellow Green) over it. The bottoms of the stems are painted in the medium tone (Green). Add a little Purple at the very top of the stems as they are shaded by the flowers.

4. Paint the leaves underneath the flower heads in the dark and light tones (Deep Green and Yellow Green).

5. Paint the leaves on the right (or dark) side partly in the dark tone (Deep Green) and partly in the medium tone (Green). Try to make the leaves look delicate.

6. Paint the leaves on the left (or light) side partly in the medium tone (Green) and partly in the light tone (Yellow Green). Paint the green buds in the dark tone (Deep Green) with Yellow Green in the centre.

As you have seen, this wasn't quite as complicated as some of the earlier ones!

Rocky Cove

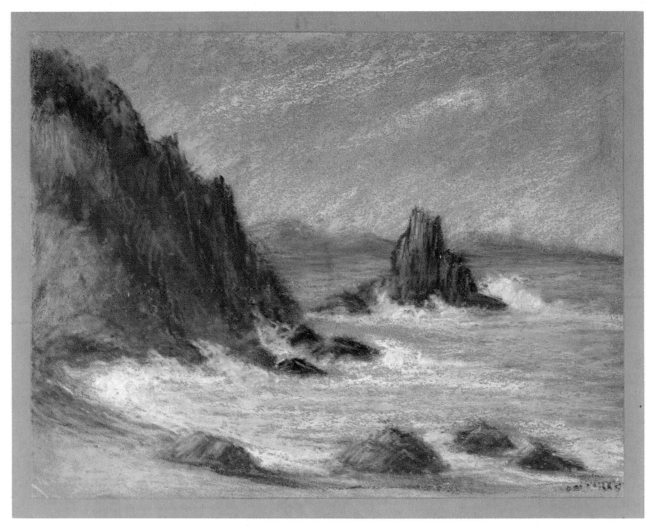

1. Use sandpaper 23×30cm (9×12in) placed horizontally.

2. Study the painting and drawings on pages 36 and 37 carefully.

3. Draw the grid lines in pencil and then, also in pencil, sketch in the simplified picture as shown opposite above.

4. The light is coming from the left (note the shadows on the right of the objects) so lightly shade these areas in pencil.

5. Take the purple pastel pencil and outline the objects and paint in the shadow lightly as shown opposite below. (Do NOT draw the grid lines in purple.)

6. Erase all the grid lines, leaving the purple outline intact (see opposite below).

THE DRAWING

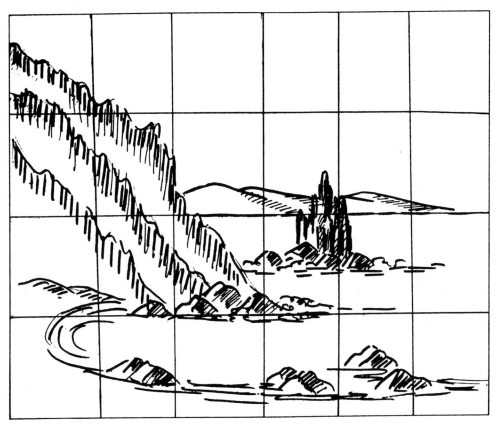

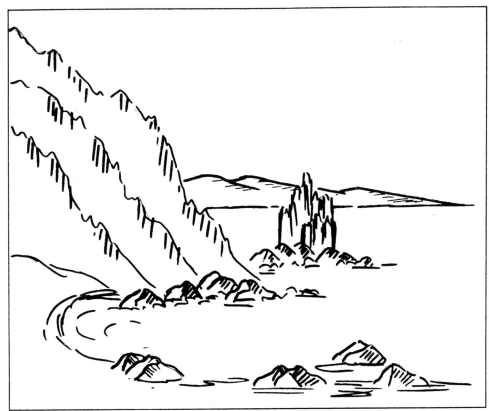

THE PAINTING

SKY

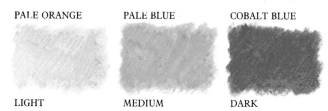

PALE ORANGE PALE BLUE COBALT BLUE

LIGHT MEDIUM DARK

1. Study the finished painting. Note that, as it is sundown, there are warm tones on the rocks and cliffs.

2. Using upward, slanting strokes paint the light tone (Pale Orange) along the top of the mountains.

3. Add the medium tone (Pale Blue) to the rest of the sky – use the same slanting, upward strokes. Paint a little of the dark tone (Cobalt Blue) along the top of the sky and blend it with the Pale Blue.

4. Using White, paint an impression of clouds drifting across the sky. Stroke the pastel from right to left.

MOUNTAINS

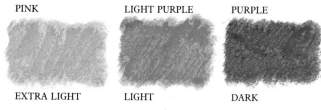

PINK LIGHT PURPLE PURPLE

EXTRA LIGHT LIGHT DARK

1. Study the finished painting.

2. Paint the dark tone (Purple) on the right (or dark) side of the mountains.

3. Paint the light tone (Light Purple) on the left side. Add a touch of Pink over the Light Purple. Highlight with a little Pale Blue.

CLIFF

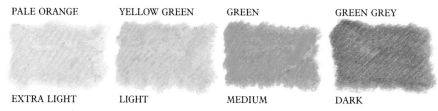

PALE ORANGE YELLOW GREEN GREEN GREEN GREY

EXTRA LIGHT LIGHT MEDIUM DARK

1. Study the finished painting. Note that the cliff is painted in 3 rough 'sections' – see second drawing.

2. Using strong, vertical strokes, paint the top section in the dark tone (Green Grey). Add Purple over this. Use the medium tone (Green) to paint the vegetation at the top and highlight with the light tone (Yellow Green).

3. Paint the middle section the same way, but add the extra light tone (Pale Orange) as a separate section at the top. Use a little Orange to highlight.

4. Paint the last section in the same way as the first, using the dark tone (Green Grey) with Purple painted over it. Keep the strokes jagged. Again add the extra light tone to the far left and highlight it with Orange. Use the light tone (Yellow Green) to paint the vegetation.

5. Use short strokes of Pale Blue and Purple as a final highlight over the cliff as shown.

BEACH

1. Study the finished painting. Use the same tones as for the cliff.

2. Paint the beach, including the area between the rocks, with the extra light tone (Pale Orange). The sandpaper should still show through. Add a little Orange also.

3. Paint Purple shadows on the right side of the rocks.

4. Using the light tone (Yellow Green) and Purple, paint some vegetation along the left side of the beach.

ROCKS

PALE ORANGE PRUSSIAN BLUE VAN DYKE BROWN

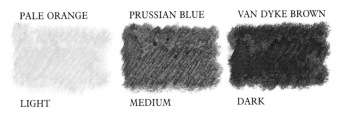

LIGHT MEDIUM DARK

1. Study the finished painting and the step-by-step illustration. Paint the large rock formation in the sea first.

2. Using vertical strokes, paint most of the rock in the dark tone (Van Dyke Brown). See the first step for details.

3. Paint the medium tone (Prussian Blue) over it, keeping it mostly to the right side. See the second stage and finished picture.

4. Paint the rocks at the base of the formation in the dark and medium tones (Van Dyke Brown and Prussian Blue).

5. Fill in the left side of the formation with the light tone (Pale Orange). Add a few jagged vertical strokes of Orange as a highlight.

6. Highlight the right side of the formation with a little black charcoal pencil and Pale Blue.

7. Paint the three rocks at the base of the cliff in the dark and medium tones (Van Dyke Brown and Prussian Blue). Add some Purple beneath them as shadow and a touch of Pale Blue as highlight.

8. Paint the rocks on the beach with the dark and medium tones (Van Dyke Brown and Prussian Blue) on the right side and the light tone (Pale Orange) on the left. Highlight the left side with a little Orange. Add Pale Blue as a further overall highlight.

SEA

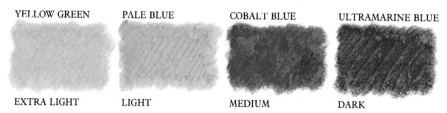

YELLOW GREEN PALE BLUE COBALT BLUE ULTRAMARINE BLUE

EXTRA LIGHT LIGHT MEDIUM DARK

1. Study the finished painting. Paint the sea in 3 horizontal 'sections' – behind the rock formation, up to the rocks at the side of the cliff and up to the beach.

2. Paint the sea along the horizon in the dark tone (Ultramarine Blue). Shade the medium and light tones (Cobalt Blue and Pale Blue) in strips up to the rock formation.

3. In the middle section paint the dark tone (Ultramarine Blue) on the right side shading to the medium and light tones (Cobalt Blue and Pale Blue) towards the base of the cliff.

4. In the last section paint the dark tone (Ultramarine Blue) on the right. Paint the extra light tone (Yellow Green) on the left and on to the beach, and shade the medium and light tones (Cobalt Blue and Pale Blue) between them. You need a lighter colour at the shoreline because the water is shallow. Use light, alternate strokes, mixing up the tones. Take care, however, not to lose the tonal values completely.

SEA FOAM

1. With a clean White pastel paint the white foam as shown. Drag the tip of the White pastel through the front and middle sections of the sea.

The Blue Hat

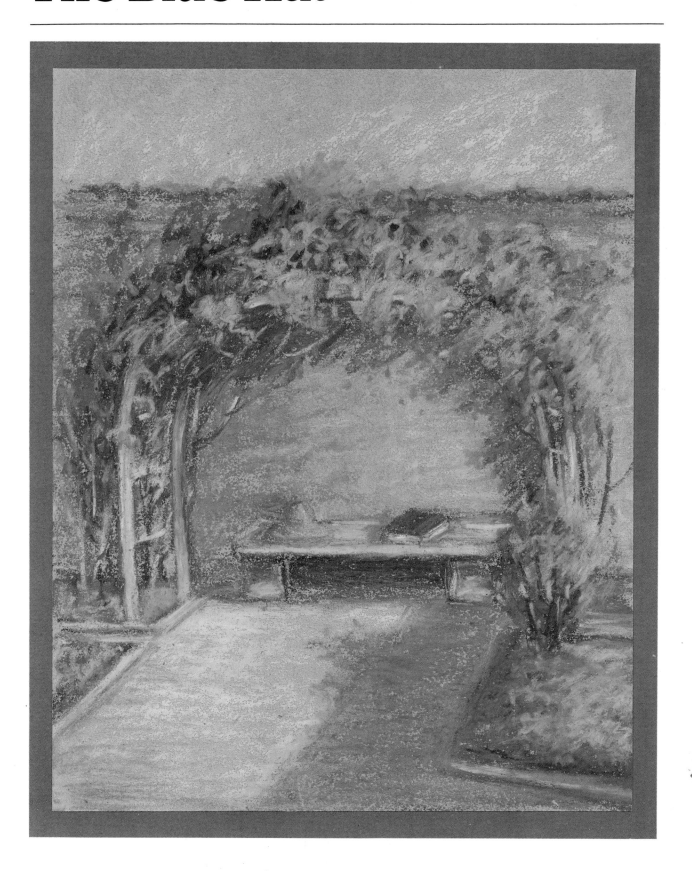

THE DRAWING

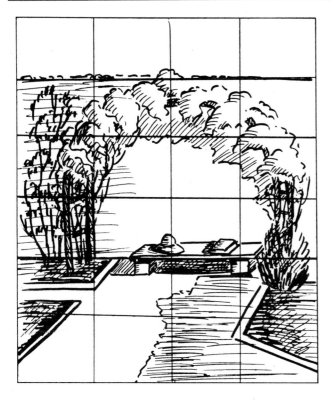 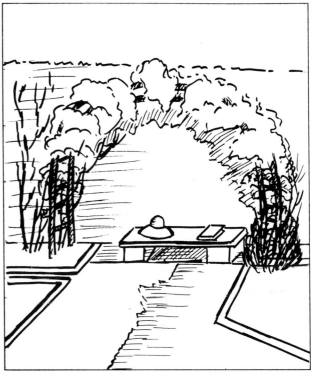

1. Use sandpaper 23×30cm (9×12in) placed vertically.

2. Study the painting and drawings on pages 41 and 42 carefully.

3. Draw the grid lines in pencil, and then, also in pencil, sketch in the simplified picture as shown above left.

4. The light is coming from the right (note the shadows on the left of the objects) so lightly shade in these areas in pencil. (The shadow on the path is coming from another wall out of the picture.)

5. Take the purple pastel pencil and outline the objects and paint in the shadow lightly as shown above right. (Do NOT draw the grid lines in purple.)

6. Erase all the grid lines, leaving the purple outline intact (see above right).

THE PAINTING

SKY

1. Study the finished picture.

2. Paint the sky in Pale Blue. The sandpaper should still show through. Paint a little White in upward slanting strokes just above the wall.

WALL

PALE ORANGE — LIGHT

YELLOW OCHRE — MEDIUM

BROWN — DARK

1. Study the finished picture.

2. Using horizontal strokes paint the entire wall in the medium tone (Yellow Ochre). The sandpaper should still show through.

3. Paint the left (or dark) side of the wall with the dark tone (Brown) but be careful not to lose the Yellow Ochre completely. Paint Brown along the top of the wall also. Note that this line should be uneven. Paint a few touches of Green on top of the wall as shown.

4. Stroke a little of the light tone (Pale Orange) on the right side of the wall and onto the wall above the bench.

PATH

1. Study the finished painting. Use the same tones as for the wall.

2. Using horizontal strokes paint the right (or dark) side of the path in the medium tone (Yellow Ochre). Shade it with Purple and Green Grey as shown. The edge of the shadow should not be straight.

3. Using horizontal strokes again, paint the left side of the path in the light tone (Pale Orange). Add a little of the medium tone (Yellow Ochre) to the left and bottom of the path.

BENCH

PALE ORANGE — LIGHT

BROWN — DARK

1. Study the finished painting.

2. Paint the top and legs of the bench in the light tone (Pale Orange). Paint the shadows of the hat and book in Purple where shown.

3. Add some Purple to the top of the legs – they are shaded by the overhang of the bench.

4. Paint a shadow under the bench with the dark tone (Brown). Add some Purple to this and also paint a little Purple under the left side of the bench and to the left side of it.

THE ARBOR

1. Study the finished painting.

2. Paint the arbor in Pale Orange. Be careful with the perspective.

3. Paint a little of the arbor showing through the leaves at the top as shown.

VINE

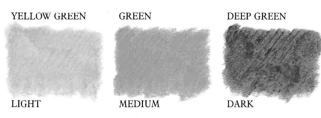

YELLOW GREEN GREEN DEEP GREEN

LIGHT MEDIUM DARK

1. Study the finished painting. Note that the leaves are only impressions and not detailed. Your strokes should be lacy and loose. Study the 2 drawings and the finished painting carefully. Notice how the vine is broken down into 'sections'.

2. Paint the far left of the vine, including the part on the wall, in the dark tone (Deep Green) with a few touches of the medium tone (Green) and the light tone (Yellow Green).

3. Paint the left side of the left curve in the dark tone (Deep Green). Shade this to the medium tone (Green) in the middle and the light tone (Yellow Green) on the right. Paint the top of the vine in Deep Green and Green, highlighted with Yellow Green.

4. Paint the right of the vine with the light tone (Yellow Green). Add a little dark tone (Deep Green) to the tips of the leaves. Separate the sections a little with Purple.

5. To paint the small bush on the right, stroke the dark tone (Deep Green) on the left side. Add the medium tone (Green) to the middle and the light tone (Yellow Green) to the right.

6. Stroke a little Brown in between the sections of vine and also underneath it.

7. Paint Light Purple on to the wall as shown, which is the shadow made by the vine.

8. Paint the branches of the vine in Brown. They are mostly on the left. Keep your strokes long and graceful. Accent the branches here and there with the black charcoal pencil. Add White as a highlight where shown.

PLANT BEDS

1. Study the finished painting. Note that the beds are not flat and that the plants are impressions and not detailed. Use the same tones as for the vine.

2. Using short strokes, paint the beds on the left with the dark tone (Deep Green). Add the medium tone (Green) on top and paint a little light tone (Yellow Green) on the edges.

3. Paint the left side of the bed on the right with the dark tone (Deep Green). Add the medium tone (Green) to the middle and the light tone (Yellow Green) to the right. Blend the colours but don't lose the tonal values completely. Add a few strokes of Purple to accent the dark tone as shown.

HAT

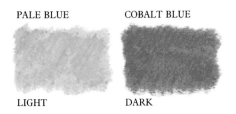

PALE BLUE COBALT BLUE

LIGHT DARK

1. Study the finished picture.

2. Paint the left side and bottom of the hat in the dark tone (Cobalt Blue).

3. Paint the rest of the hat in the light tone (Pale Blue).

BOOK

1. Study the finished picture.

2. Paint the cover of the book in Brown and the edges in Orange.

3. Paint a little White on the sides of the book for pages. Outline lightly in black charcoal pencil, if necessary.

Springtime in New York

1. Use light blue Ingres pastel paper or sugar (construction) paper 23×30cm (9×12in) placed horizontally.

2. Study the painting and drawings on pages 45 and 46 carefully.

3. Draw the grid lines in pencil and then, also in pencil, sketch in the simplified picture as shown overleaf above.

4. The light is coming from the right (note the shadows on the left of the trees) so lightly shade in these areas in pencil.

5. Take the purple pastel pencil and outline the objects and paint in the shadow lightly as shown overleaf below. (Do NOT draw the grid lines in purple.)

6. Erase all the grid lines, leaving the purple outline intact (see overleaf below).

THE DRAWING

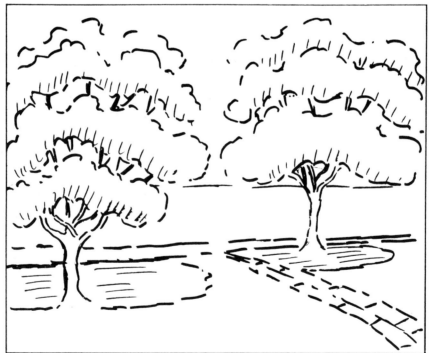

THE PAINTING

BACKGROUND LAWN

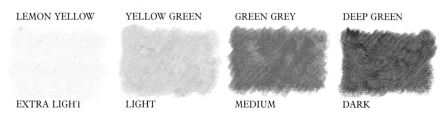

LEMON YELLOW YELLOW GREEN GREEN GREY DEEP GREEN

EXTRA LIGHT LIGHT MEDIUM DARK

1. Study the finished painting.

2. Paint the right side of the lawn behind the trees in the medium tone (Green Grey). Use horizontal strokes. Stroke a little Purple over the Green Grey, but don't cover it completely.

3. Paint the left side of the background lawn in the light tone (Yellow Green) and paint the extra light tone (Lemon Yellow) over it.

4. Paint a faint impression of more trees in the background by stroking the dark tone (Deep Green) just below the branches of the white tree. With light, short strokes paint Green Grey, Deep Green and Purple above the white tree and a very little Green Grey and Yellow Green above the pink tree. Patches of the blue paper should still show through.

PATH BEHIND TREES

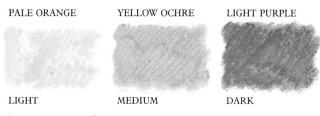

PALE ORANGE YELLOW OCHRE LIGHT PURPLE

LIGHT MEDIUM DARK

1. Study the finished picture.

2. Paint the far right of the horizontal path in the medium tone (Yellow Ochre), as far as the white tree.

3. Paint the middle section of the path in the light tone (Pale Orange).

4. Paint the far left of the path with the medium tone (Yellow Ochre). Paint the dark tone (Light Purple) over it.

FOREGROUND LAWN

1. Study the finished picture. Note that the lawn is split into left and right 'sections' by the narrow path running between the trees. Use the same tones as for the background lawn.

2. Paint the right side of the lawn around the white tree with the dark tone (Deep Green). Shade the far right in the medium tone (Green Grey). Add Purple to the Deep Green under the tree, but be careful not to lose the tonal values.

3. Paint the small bush on the right in the dark tone (Deep Green). Tip it with the medium tone (Green Grey).

4. Paint the left side of the lawn around the pink tree with the dark tone (Deep Green). Shade this to the light tone (Yellow Green) at the front of the lawn. Add Purple to the Deep Green under the tree but be careful not to lose the tonal values.

PATH BETWEEN TREES

1. Study the finished picture. Note that the path is wider at the far right than in the centre, where it meets the larger path.

2. Very lightly paint an impression of stones with a little Green. Paint a little Grey on the stones at the top of the path, and Lemon Yellow on the bottom stones. Keep your strokes soft so that the path is rather indistinct.

WHITE TREE

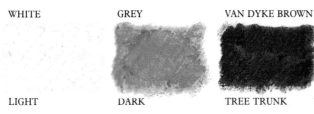

WHITE GREY VAN DYKE BROWN

LIGHT DARK TREE TRUNK

1. Study the finished picture and the step-by-step illustration for the pink tree. The same method applies to both trees. The blossom is painted in 'layers' as were the leaves of the trees you have painted previously. Note that the white tree, being further away, is slightly smaller than the pink tree.

2. Paint the trunk and lower branches in Van Dyke Brown. Outline the trunk here and there with the black charcoal pencil for accent.

3. Paint the bottom of each layer of blossom in the dark tone (Grey). Keep your strokes fan-like and slightly separate.

4. Paint the tops of the layers in White. Use the same fan-like strokes to make the blossom look soft.

5. Use the Van Dyke Brown to paint a few delicate branches through the blossom as shown. Accent the branches here and there with black charcoal pencil.

PINK TREE

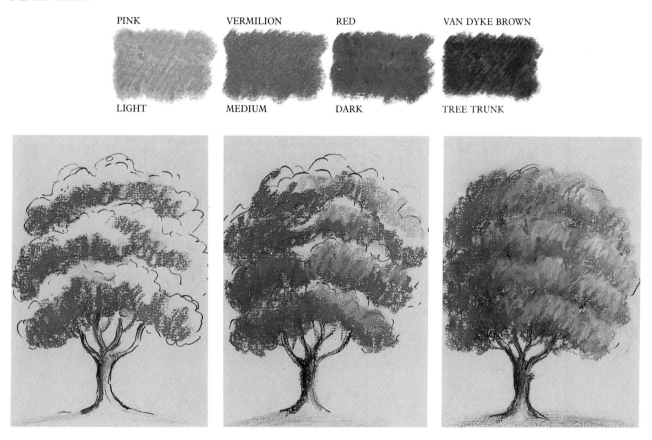

1. Study the finished painting and the step-by-step illustration. Note that the 'layers' of blossom can also be divided into left and right sides – the left being the dark (or shady) side. Make sure that you allow some blue paper to show through the blossom for sky. Paint the trunk and lower branches in Van Dyke Brown. Outline the trunk and branches here and there with the black charcoal pencil. Try to give the tree a 'gnarled' look. Highlight the base of the tree and the branches on the right with Pale Orange and the left side with Pale Blue.

2. Paint the layers of blossom on the left side with the dark tone (Red) at the bottom and the medium tone (Vermilion) at the top.

3. Paint the layers of blossom on the right with the medium tone (Vermilion) on the bottom and the light tone (Pink) at the top. Highlight these blossoms with White.

4. Use the Van Dyke Brown to paint a few delicate branches here and there with black charcoal pencil.

This is an especially lovely painting and well worth the effort.

Sailing on Lake Como

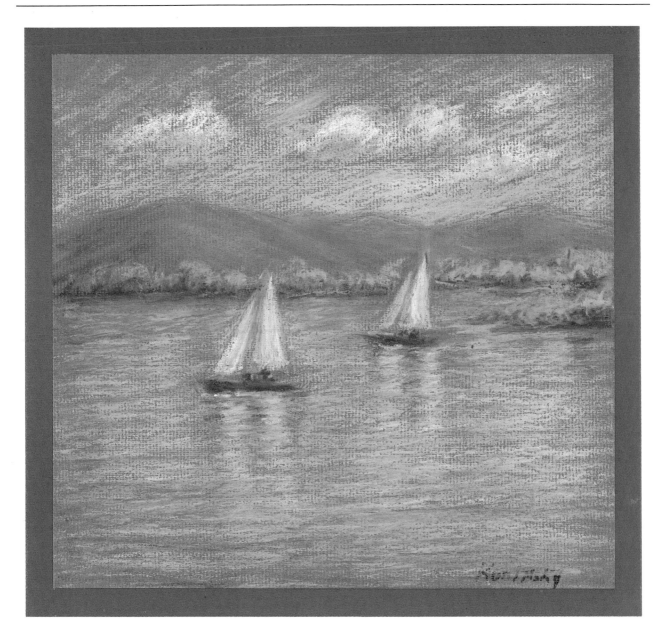

1. Use light blue Ingres paper or sugar (construction) paper 23×30cm (9×12in) placed horizontally.

2. Study the painting and drawings on pages 50 and 51 carefully.

3. Draw the grid lines in pencil and then, also in pencil, sketch in the simplified picture as shown opposite above.

4. The light is coming from the right (note the shadows on the left of the mountains) so lightly shade in these areas in pencil.

5. Take the purple pastel pencil and outline the objects and paint in the shadow lightly as shown opposite below. (Do NOT draw the grid lines in purple.)

6. Erase all the grid lines, leaving the purple outline intact (see opposite below).

THE DRAWING

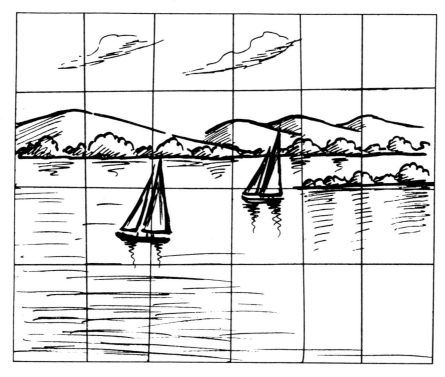

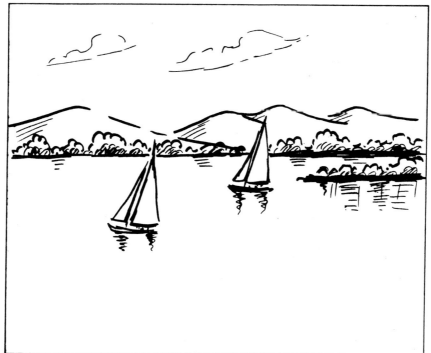

THE PAINTING

SKY

WHITE PALE ORANGE PALE BLUE

LIGHT MEDIUM DARK

1. Study the finished painting.

2. Paint Pale Orange along the mountains with upward slanting strokes.

3. Paint the rest of the sky in Pale Blue, blending it with the Pale Orange.

4. Using rounded strokes, paint the underside of the clouds in Grey and the tops of the clouds in White.

MOUNTAINS

LIGHT PURPLE PURPLE

LIGHT DARK

1. Study the finished painting. Note that the mountains should look hazy.

2. Using light strokes, paint the left side of each mountain in Purple.

3. Paint the right side of each mountain in Light Purple.

4. Lightly add a little Pale Orange to the Light Purple and add a few strokes in between the mountains.

TREES

YELLOW GREEN GREEN DEEP GREEN

LIGHT MEDIUM DARK

1. Study the finished painting. Notice that the trees can be painted in 3 'sections', using the boats as dividing lines.

2. Paint the base of the left section of trees in the dark tone (Deep Green). Paint the top of this section in the

medium tone (Green). Use half-circular strokes which suggest trees of varying heights.

3. Paint the base of the middle section of trees in the medium tone (Green). Paint the top of this section in the light tone (Yellow Green).

4. Paint the 2 remaining sections of trees with the light tone (Yellow Green) at the base and Lemon Yellow on the top.

5. Add a line of Purple along the shoreline underneath the trees. Soften it with a touch of Pale Blue.

LAKE COMO

YELLOW GREEN | PALE BLUE | COBALT BLUE

LIGHT | MEDIUM | DARK

1. Study the finished painting. This is not easy – the aim is to make the lake look full of reflections and shimmering light!

2. Paint a strip of dark tone (Cobalt Blue) underneath the trees.

3. Paint an area of dark tone (Cobalt Blue) underneath the left side of the left mountain as shadow. Then, using horizontal strokes, paint the dark tone (Cobalt Blue) down the left side of the lake, across the bottom and up the right side to the trees.

4. Paint the medium tone (Pale Blue) over the entire lake in long horizontal strokes.

5. Using short, horizontal strokes paint a strip of dark tone (Cobalt Blue) just to the left of the larger boat. Take the strip from the shoreline to the bottom of the lake. Paint a similar strip between the two boats and again to the right of the smaller boat.

6. Using White, paint two long reflections under each boat as shown. Paint similar reflections on the right and left sides of the lake.

7. Using long strokes paint reflections in the light tone (Yellow Green) on the left side of the lake and on the right side under the trees. Also paint long strokes of Yellow Green across the bottom of the lake.

8. Paint a few strokes of the dark tone (Cobalt Blue) between the two reflections of each boat.

9. Add further horizontal strokes of White and Yellow Green over the whole of the lake. Accent with Light Purple underneath the boats, where the mountains form a shadow on the water and over the surface of the lake as shown.

BOATS

WHITE | VAN DYKE BROWN

LIGHT | DARK

1. Study the finished painting. Note that the sails lean slightly to the right and that they look full of movement. You do not need to paint a mast between the sails.

2. Paint the boats in Van Dyke Brown with a touch of Orange as highlight. Make the boats long and delicate in shape. Add tiny strokes of Purple to suggest people on board.

3. Paint the sails in White, highlighted with Pale Orange and Yellow Green. Use White to paint a suggestion of a bow wave under the boats.

White Birches

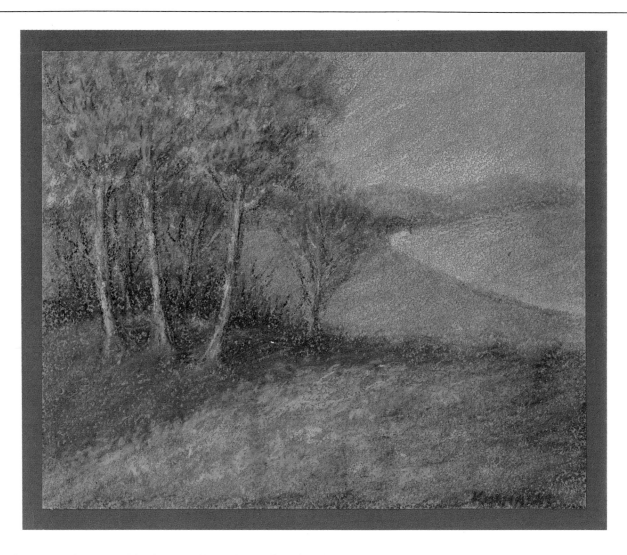

1. Use sandpaper 23×30cm (9×12in) placed horizontally.

2. Study the painting and drawings on pages 54 and 55 carefully.

3. Draw the grid lines in pencil and then, also in pencil, sketch in the simplified picture as shown opposite above.

4. The light is coming from the left (note the shadows on the right side of the trees) so lightly shade in these areas in pencil.

5. Take the purple pastel pencil and outline the objects and paint in the shadow lightly as shown opposite below. Don't outline the top branches of the trees, you will paint the sky first and add the branches later (see second drawing).

6. Erase all the grid lines, the small trees and the top branches of the birches, leaving the purple outline intact (see opposite below).

THE DRAWING

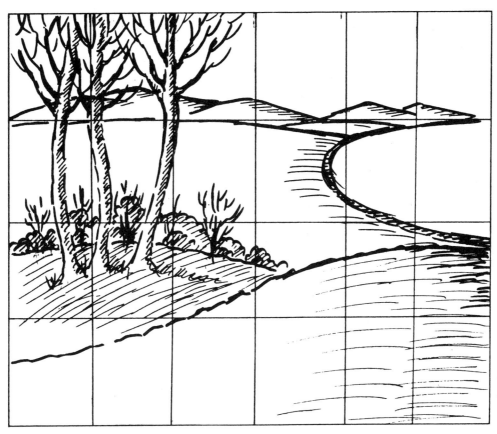

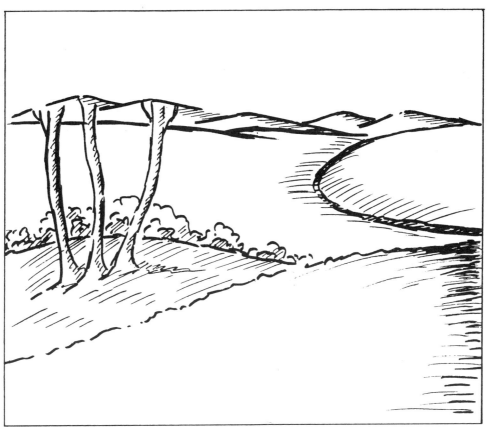

THE PAINTING

SKY

PALE ORANGE PALE BLUE

LIGHT DARK

1. Study the finished painting.

2. Using upward, slanting strokes paint Pale Orange along the tops of the mountains.

3. Paint Pale Blue over the rest of the sky, blending it with the Pale Orange.

MOUNTAINS

PINK LIGHT PURPLE

LIGHT DARK

1. Study the finished painting. Note that the mountains behind the trees are closer than the others

and darker in tone.

2. Paint the right side of the mountains on the right in Light Purple and the left side in Pink.

3. Paint the mountains behind the trees in Purple as shown.

4. With purple pastel pencil draw in the branches which you erased earlier.

BACKGROUND HILLS AND ROAD

YELLOW OCHRE YELLOW GREEN GREEN GREY

LIGHT MEDIUM DARK

1. Study the finished painting. Note that there are two hills either side of the curving road.

2. Paint the right side of the hill on the right in the dark tone (Green Grey). Shade the left side up to the

road in the medium tone (Yellow Green).

3. Paint the right side of the hill on the left in the dark tone (Green Grey). Shade a little of the right side in the light tone (Yellow Ochre) also.

4. Paint the rest of the hill in the light tone (Yellow Ochre). Take the colour right through the vegetation behind the birches – you can paint these in later.

5. Paint the road in Yellow Ochre and stroke Pale Orange around the top curve.

FOREGROUND HILLS

LEMON YELLOW YELLOW GREEN GREEN GREY

LIGHT MEDIUM DARK

1. Study the finished painting. Note that the ground beneath the trees is in distinct shadow. Try to give the impression of uneven grassy terrain.

2. Paint the right side of the foreground with the dark tone (Green Grey). Shade the area towards the trees in the medium tone (Yellow Green).

3. Stroke Purple over the Green Grey but be careful not to lose the Green Grey completely.

4. Paint alternate strokes of Lemon Yellow and Yellow Ochre over the Yellow Green.

5. Paint the area around the trees in the dark tone (Green Grey) and paint Purple over it. Add strokes of Brown as well as shown. Make sure your strokes slope to the left.

6. Paint dark shadows behind each tree with Purple and Prussian Blue. Stroke a little Pale Blue over the whole of the foreground as shown.

SMALL BACKGROUND TREES

GREEN GREY BROWN PURPLE

LIGHT MEDIUM DARK

1. Study the finished painting. Note that the trees are of different heights.

2. Using Brown and Purple paint a dark shadow at the base of the line of small trees.

3. Paint the foliage of the trees with Green Grey. Keep the leaves soft and hazy.

4. Paint an impression of brush and also the small tree on the right with Brown. Outline the brush and small tree here and there with black charcoal pencil as shown.

BIRCHES

YELLOW GREEN GREEN DEEP GREEN

LIGHT MEDIUM DARK

1. Study the finished painting. Note that the trees are slender and graceful – don't line them up like soldiers! Note also that the foliage should be lacy and soft.

2. Paint the trunks and some branches with Grey. Highlight the trunks with Pale Orange as shown.

Outline the right side of the trunk and some of the branches with black charcoal pencil. Add a little Pale Blue as a further highlight.

3. Use the same technique for painting the trees as you used in *Summertime*. Refer to the step-by-step illustration on page 20 if necessary. Paint the dark tone (Deep Green) on the right of the trees and across the branches. Add a little Purple over this.

4. Stroke the medium tone (Green) on the left of the tree and over the Deep Green. Then add the light tone (Yellow Green) on top. Highlight the leaves here and there with Pale Orange and Pale Blue as shown.

Fruit and Flowers

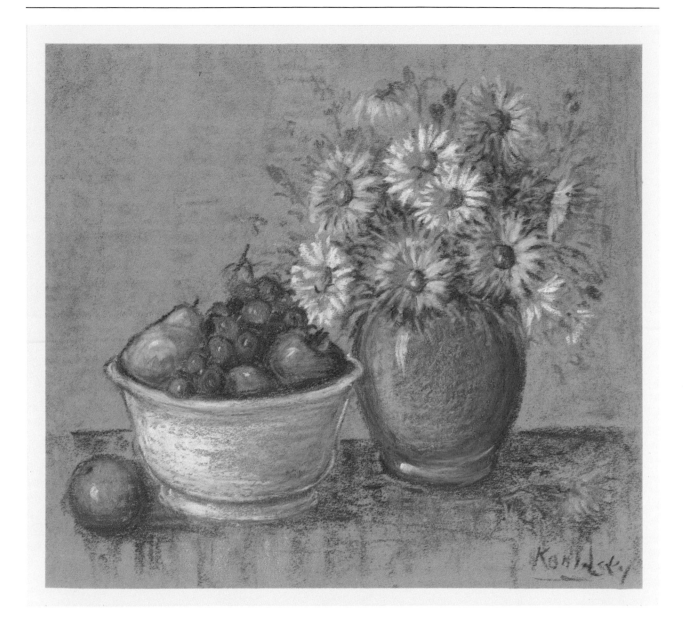

1. Use sandpaper 30×35cm (12×14in) placed horizontally.

2. Study the drawings and painting on pages 58 and 59 carefully.

3. Draw the grid lines in pencil and then, also in pencil, sketch in the simplified picture as shown opposite above. You can place the blue vase more easily if you draw a box around it as shown in the second drawing.

4. The light is coming from the left (note the shadows on the right of the objects) so lightly shade in these areas in pencil.

5. Take the purple pastel pencil and outline the objects and paint in the shadow lightly as shown opposite below.

6. Erase all the grid lines, leaving the purple outline intact (see opposite below).

THE DRAWING

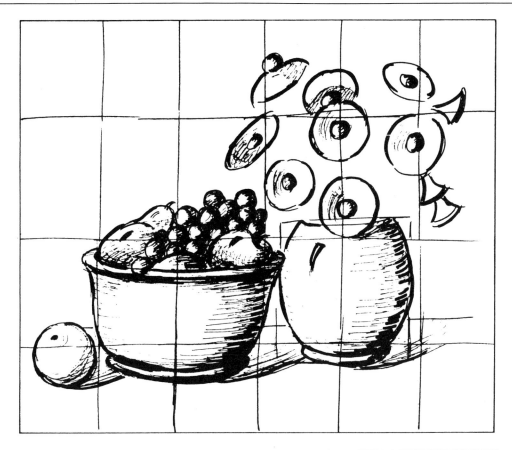

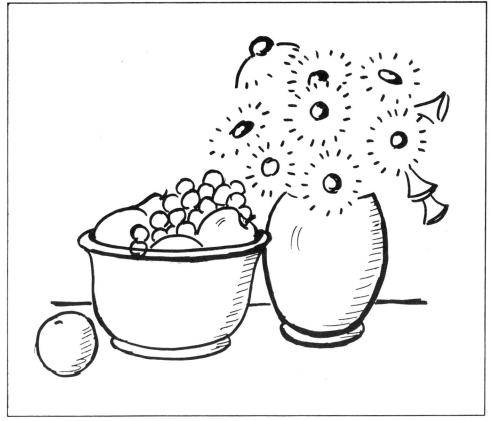

THE PAINTING

BACKGROUND

1. Study the finished painting. Note that the sandpaper forms the major part of the background.

2. With the flat side of the Yellow Ochre pastel paint long vertical strokes over the background as far as the table.

3. With the flat side of the Orange pastel paint long vertical strokes lightly over the Yellow Ochre. You will, of course, have to remove the paper wrapper if you have not already done so.

4. With the flat side of the Purple pastel paint in an impression of a table using horizontal strokes. Also paint in the shadows – these are mostly on the right side of the orange, the bowl and vase and under the single flower. Stroke a few Purple vertical lines under all the objects as shown.

BLUE VASE

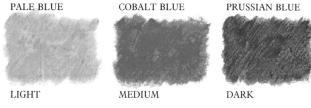

PALE BLUE COBALT BLUE PRUSSIAN BLUE

LIGHT MEDIUM DARK

1. Study the finished painting. Note that you should keep your strokes slightly rounded to achieve the rounded form of the vase.

2. Paint the right side of the vase in the dark tone (Prussian Blue). Paint the ridge at the very bottom of the vase and the area above it in the Prussian Blue also. Paint a little of the medium tone (Cobalt Blue) on the left side of the vase.

3. Paint the medium tone (Cobalt Blue) in the middle of the vase and the light tone (Pale Blue) on the left side.

4. Add a little medium tone (Cobalt Blue) to the Pale Blue on the extreme left of the vase but be careful not to lose the Pale Blue completely.

5. Add a little Yellow Green to the Pale Blue on the left of the vase.

6. Paint White highlights on the vase as shown. Press down hard on the pastel for a strong colour.

WHITE BOWL

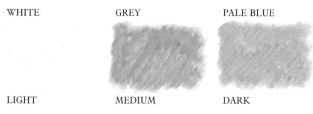

WHITE GREY PALE BLUE

LIGHT MEDIUM DARK

1. Study the finished painting. Make your strokes rounded once again.

2. Paint the right side of the bowl, including the right side of the ridge, in the medium tone (Grey). Stroke the dark tone (Pale Blue) under the lip of the bowl, along the right side, across the bottom and on the ridge. Do not entirely cover the Grey on the ridge.

3. Paint the rest of the bowl and ridge in the light tone (White).

4. Paint the right of the lip in the medium tone (Grey) and the left in White.

YELLOW DAISIES

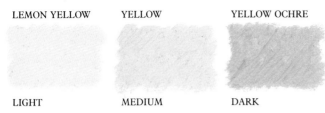

LEMON YELLOW YELLOW YELLOW OCHRE

LIGHT MEDIUM DARK

1. Study the finished painting. Note that all the yellow daisies are painted in the same way except for those in profile.

2. Paint the petals on the left in the dark tone (Yellow Ochre). Paint Orange over them as shown.

3. Paint the petals on the right in the medium tone (Yellow). Tip the petals with the light tone (Lemon Yellow).

4. Paint the centres with Brown on the right side and Orange on the left. Add a highlight of Lemon Yellow. Outline the right side of the centres in the purple pastel pencil.

5. Paint the right side of the profile daisy on the right with the dark tone (Yellow Ochre). Paint the overlapping petals with the medium tone (Yellow) as shown.

6. Paint the right side of the profile daisy at the top in the dark tone (Yellow Ochre). Paint the left petals in the medium tone (Yellow). The centre is Brown and Orange.

WHITE DAISIES

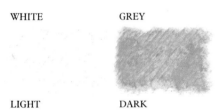

WHITE GREY

LIGHT DARK

1. Study the finished painting. Note that all the white daisies are painted in the same way except for those in profile.

2. Paint the petals on the left in Grey. Tip them with White.

3. Paint the petals on the right in White.

4. Paint the centres with Brown on the right side and Orange on the left. Add a highlight of Lemon Yellow. Outline the right side of the centres in the purple pastel pencil.

5. Paint the right side of the profile daisies with Grey. Paint the overlapping petals in White.

6. Carefully stroke Purple between the flowers and into the edges of the petals as shown.

LEAVES

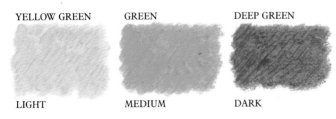

YELLOW GREEN GREEN DEEP GREEN

LIGHT MEDIUM DARK

1. Use the dark and medium tones (Deep Green and Green) to paint the leaves extending from the flowers as shown. Keep the leaves delicate and lacy. Add the light tone (Yellow Green) to the leaves on the left. Paint touches of Pale Blue here and there between the flowers.

APPLE

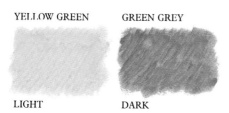

YELLOW GREEN	GREEN GREY
LIGHT	DARK

1. Study the finished painting.

2. Paint the right side and bottom of the apple and the left side of the stem area with Green Grey. Keep your strokes rounded.

3. Paint the rest of the apple and the right side of the stem area in Yellow Green. Paint the stem with the purple pastel pencil. Add a White highlight as shown.

ORANGES

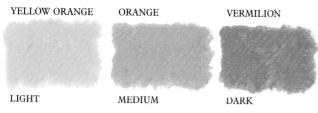

YELLOW ORANGE	ORANGE	VERMILION
LIGHT	MEDIUM	DARK

1. Study the finished picture.

2. Paint the top of the orange in the bowl in the light tone (Yellow Orange) and the rest of it in the medium tone (Orange). Add a tiny White highlight as shown.

3. Paint the right side of the orange on the table with the dark tone (Vermilion), shading to the medium and light tones (Orange and Yellow Orange) at the top. Paint a small dot of Purple on the stem and also a White highlight as shown.

PEAR

YELLOW	YELLOW OCHRE
LIGHT	DARK

1. Study the finished painting.

2. Paint the right side of the pear in Yellow Ochre and the left side in Yellow. Add a touch of Orange to the Yellow Ochre. Paint a White highlight at the top and bottom of the pear as shown.

GRAPES

PINK LIGHT PURPLE PURPLE

LIGHT MEDIUM DARK

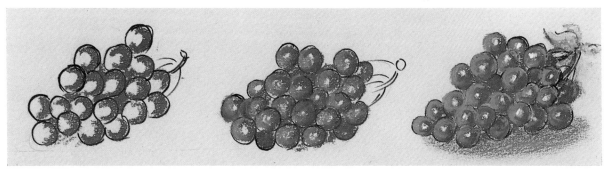

1. Study the finished painting and the step-by-step illustration.

2. Paint a line of Purple around the bunch of grapes where they rest on the other fruit in the bowl.

3. Outline the grapes again with the purple pastel pencil.

4. Paint the right side of the grapes in the dark tone (Purple) and the left side in the medium tone (Light Purple) – see the first and second steps.

5. Add a little light tone (Pink) to the Light Purple, but be careful not to lose the colour completely. Add a touch of Pale Blue to the Purple. Paint a dot of White in the middle of each grape as a highlight – see the third step.

6. Stroke the Pale Blue here and there around the other fruit for accent.

7. Paint the stem of the fallen flower with Deep Green and touches of Yellow Green as shown. The flower is painted in Orange and Yellow Orange.

8. Paint a few vertical strokes of Pale Blue under the blue vase and similar strokes of White under the white bowl. These are reflections.

This is the most ambitious painting in the book but I'm sure you will be very pleased with the finished result – and with all the other paintings you have done. You will now have the confidence to paint on your own, using this book for guidance and inspiration. Happy Painting!